"As a superintendent of schools for 17 years, I constantly sought information on how teachers could build and evaluate students' creativity. Dr. Jones and Dr. Escue, both of whom have public school and higher education backgrounds, have provided classroom teachers with an insightful guide in building and evaluating the natural creativity of children and youth."

— Dr. Billy Mitchell, author of *Power of Positive Students* and *Positive Parenting*, Myrtle Beach, SC.

"This program has a very strong theory base and is very developmentally appropriate. A program like this is needed to refocus us all on creativity."

— Dr. Irene Mossburg, coordinator of staff development for Regional Educational Service Agency (RESA IV), WV.

Positive Creativity— How to Enhance and Evaluate It

Jerry Dale Jones
and
Billy N. Escue

Creative Innovations

8015 Warner Road
Brentwood, TN 37027

Printed in the United States of America

*This book is dedicated
to our students,
from whom we continue to learn
even after they graduate.*

*Creativity
is far more significant
than knowledge
in the advancement
of humankind.*

Albert Einstein

Table of Contents

Format 1
Introduction 3
A Teacher's View of Creativity in the Classroom 11
Creativity—Evaluation of Teachers and Program 15
Pre and Post Assessment 19
Scope and Sequence Chart 21

Workshop 1: Development Theory 23

Objectives
Suggested Workshop Procedures for Facilitators
Theories of Children's Art
Intellectual Development Stages from the Writings of Jean Piaget
Developmental Information
Hierarchy of Creative Skills
Maslow's "Hierarchy of Needs" Theory of Human Motivation

Workshop 2: Creative Thinking Skills 47

Objectives
Suggested Workshop Procedures for Facilitators
Creating an Atmosphere for Creative Thinking
Developing a Low-Risk Environment
Sociogram
Sensory Discovery Lists
Awareness Development Activities

Workshop 3: Creative Visual Expression 77

Objectives
Suggested Workshop Procedures for Facilitators
Motivational Resources
Sample Lessons
Art Media
Art Supplies
Finger Paint Recipes

Workshop 4: School and Community *103*

Objectives
Suggested Workshop Procedures for Facilitators
Creative Traits—A Guide for Parents
Pre and Post Assessment

Bibliography *115*

Format

This curriculum can be implemented into any school system, individual school in-service, or college classroom. Implemented within this curriculum is a comprehensive evaluation system using Scriven's work as a model. The theory in the area of child development has been based on the works of Jean Piaget. A scope and sequence chart has been included so it can easily be implemented with objectives, procedures, activites, and materials.

Creativity is the ability to produce a new design, an original work, or an invention through imaginative skills; the expression of oneself is the most personal function of the human organism. It is for these reasons a curriculum is needed to develop creative awareness by outlining a strategy by which teachers may guide children in visual expression.

Using a variety of techniques toward learning creativity, a curriculum is proposed whereby, at each developmental level, children, as creative learners, will learn by "questioning, inquiring, searching, manipulating, and experimenting."

It is the philosophy of this program that the *teachers* will be the prime catalysts, functioning under the idea that creative guidance begets creativity. In this creative program, it is important for the teacher to be totally conscious of the physical, emotional, social, and mental needs at each level in order to bring about the development of creativity in each child.

Through this creative curriculum, you will begin to be able to compensate in some part for society's increased standardization and mechanization. This curriculum can work and be of value to you and your students.

Jerry Dale Jones, Ed.D.
Billy N. Escue, Ph.D.

Introduction

Who is Creative? Everyone!

All individuals begin with the capability of being creative. Research shows that success often depends on how well this creative aspect is allowed freedom. Freedom to create produces more creativity. Creativity produces a good self-image. Feeling good about oneself brings about success in school, in personal experiences, and eventually in careers.

Teacher training often ignores the importance of this aspect of a child's development; instead it focuses on the rigid structure of academic learning. It is believed that developing a creative and positive environment does not diminish the basic concept of education, but in actuality improves student performance.

A Neglected Area

Teacher awareness of how to encourage the development of a child's original creativity is the basis of the well-adjusted adult.

Experts have found that the human brain is divided into two separate and unique areas—the left and right hemispheres. The left hemisphere of the brain controls the cognitive areas. It is this area that teachers are trained to teach and students are taught to master. The left hemisphere, from day one, has been emphasized, and traditionally teachers have been instructed and administrators have been given the charge to teach the content areas.

Schools today are not trained to spend time on development of the right hemisphere of the brain. We need a new awareness to this reality. The person without vision is going to perish. Generally, daily living is governed by the right hemisphere. The seat of all habits and actual physical health might depend upon encouraging and working with students in development of the right hemisphere of the brain. It is this area that controls our imagination and expectations. Medical doctors are now seeing, on a daily basis, how a positive imaginative attitude influences the recovery process of patients. People who see

unimaginative, negative images often live desperate lives. They lack the necessary spark to see all the possibilities.

In looking at great athletes we see examples of creativity and imagery. Seko, the great Japanese distance runner, winner of the 1987 Boston Marathon, before the race, went over the 26-mile and 385-yard course in his mind to create feelings of success as well as the pain. Successful professional golfers would agree that visualizing beforehand the ball actually rolling, breaking, and finally dropping in the hole greatly enhances the probability of making a putt.

Why do we have to wait until we are adults to see or discover this information? We have, as individuals and as a society, had our imagination suppressed. A great need exists to begin working as early as possible with the creativity that we all possess. The sad truth is that research indicates that imagination is basically suppressed by the time a student reaches the third grade. Likewise, research indicates that fifty percent of all children are negatively altered by the time they are in the fourth grade. We are rapidly destroying creativity in the youth of our country. We need a new awareness in working with our youth.

Recently, teachers have expressed a real concern that they saw as teachers. The magic and creativity of students had regressed. The students no longer were able to show imagination, creativity, and self-confidence. The teachers felt something needed to be done.

They felt that children, when encouraged to expand creatively, grow in building character and the capacity for a broader, happier life. Genuine appreciation for the attuned things that children do and an honest desire to find out how they go about nourishing their minds is an important job of a teacher. The potentialities of youth is a serious matter.

Teaching can be a wonderfully creative profession. To be truly creative, however, the job calls for resourcefulness and a measure of ingenuity. If these ingredients are missing no amount of reward will compensate for their absence. A great effort should be made to have the kind of classroom that bends, changes, modifies, and adapts to where children are and takes them as far as possible on their journey in life.

This program is designed to enhance that goal. Workshops or classes seek to increase the possibilities for the selection of ap-

propriate and alternative teaching strategies. (Jones 1987) We hope this series of workshops will make a difference.

Creativity Is Widespread

In ancient times creativity was related to the concept of "genius." Today researchers look at creativity as a basic human endowment and not as an advantage of the elite. (Dormen and Edidin, 1989) Dean Simonton, professor of psychology specializing in studies on creativity and genius, states that there is no correlation between creativity and IQ. The average college graduate's IQ is 120 which is high enough to write novels, to do scientific research and to do other creative works. Ausebel (1964) describes creativity as one of the most vague, ambiguous and confused terms in education and psychology.

A creative behavior is defined as simply approaching the solution to a problem in a novel way that has value to society at large. (Glover and Bruning, 1990) In addition, this statement, "creativity is one of the most highly valued of human qualities," demonstrates the importance of the teacher to develop creative qualities in their students. (Dormen and Edidin, 1989) However, teachers need a basic understanding of all aspects of creativity to enhance ingenuity in the classroom. With this knowledge they should understand how creativity can be evaluated in students.

Nurturing creative abilities in students requires an understanding of the factors that make creative people unique. John R. Hayes' studies on outstanding creative people found the common grounds among them were knowledge, intelligence, and motivation. For instance, to be highly creative, a person must spend time to develop knowledge in his field of interest. Simonton says great geniuses make mistakes. Since they are constantly developing new ideas, they tend to accept their mistakes. (Simonton, 1988) Ruth Richards, another creativity researcher, similarly says that "the ability to adapt to change is the very essence of human survival." (Dormen and Edidin, 1989)

According to Einstein, creativity is far more significant than knowledge in the advancement of humankind. Notwithstanding, all of the above components of creativity are necessary for progress. (Glover and Bruning, 1990) In the same vein Benjamin Franklin's saying,

"Necessity is the mother of invention," motivated the rapid growth of the United States into a major world power. In the following pages, various instruments of creativity will be discussed. These should demonstrate how to implement creativity in the classroom as well as how to evaluate it. Wallas' four stages of the creative process; ordinary creativity; peak periods of creative growth; creative teaching; computers as a creative tool; and evaluating creativity are all forthcoming.

Instructors should be aware of Wallas' (1926) four stages of the creative process. These stages can apply to the teacher's creative needs as well as the needs of their students. In the *Preparation Stage* the problem is developed and solving is attempted. In the *Incubation Stage* other things are considered while the problem purposely is set aside. In the *Illumination Stage* a greater insight to the problem is achieved. In the *Verification Stage*, the solution is tested and carried out. (Solso, 1988) Even though Wallas developed these four stages over sixty years ago, they still can apply to today's lifestyles.

Ordinary creative thinking is a proposed point of view that ordinary people can think in odd, unusual or novel ways as they encounter everyday problems. Educators should apply this concept by teaching students to solve mundane problems in a creative manner. People with ordinary creativity are more clever problem solvers, more open to new experiences, and more apt to take higher risks than their less creative counterparts. Hence, all humans are capable of some degree of creativity in encountering everyday problems, not necessarily dealing with specific fields of endeavors. (Ripple, 1989) For example, it is well known that industry likes to locate in rural areas because people who live there are resourceful in solving their needs with what they have at hand.

Teachers experiencing peak periods of creative growth are better able to better understand the creative expectations of their students at their respective ages. Dacey says the most crucial period of creative growth is the first year and a half of life because of the development in the brain of the microneurons. He further states these microneurons are physical factors in the creative development of a child. (Dacey, 1988) In general, children born in lower socioeconomic households have minimal development of the microneurons, so they rarely make creative contributions to society. This is because the two aspects of mental function are inconvenienced by the environment: the ability to take in information and the ability to process it. In the

1960s a study of institutionalized "deprived" children indicated a sharp negative contrast in their abilities as compared with non-institutionalized children of same age. (Dacey, 1989) According to Dacey, there needs to be a better understanding of the development of micro-neuronal growth patterns.

Another facet of the brain that needs further study is the function of the left and right hemispheres. Rote memory, cognitive processes and the "three Rs" take place in the left hemisphere of the brain, which in turn controls the right side of the body. Activities such as creativity, problem solving, interactions and decision making occur in the right hemisphere of the brain which in turn governs the left side of the body. Teachers justly deal with the left hemisphere. They need to find a way to exercise the right hemisphere because the major part of daily living is governed by the right hemisphere.

Experts say that after five years of age it is difficult to develop a person's creativity. From ages 10 to 14 years, females are more likely to cultivate creative abilities a year sooner than their male counterparts. Since both Dacey and Ripple (1980) agree that teens are learning about and becoming aware of self-concept, this is optimum time to promote creativity. In ages 18–20 the most important goal is independence from parents. In the early adult transition phase, the student is ready to leave the pre-adult world to explore and participate in the adult world before fully entering this world. By entering this adult world, the early adult transforms into his own self image. This can be the appropriate atmosphere for creativity to emerge, especially if opportunity and encouragement are present. (Dacey, 1989) In 1966 Dennis's study found that the peak period of creativity is between 40s and 60s. Other studies show creative people produced as much in their 70s as they did in their earlier years. (Dennis, 1966)

Teachers Can Make a Difference

Creative teaching takes place when an educator teaches a subject in a manner that aids the students to correlate this information to solve new problems, innovatively. Creative learning takes place when students actively participate in problem solving. Four conditions for creative teaching that we will be concentrating on are:

1. The material to be taught should be meaningful.

2. The student must undertake active learning processes.
3. The instructional method must be intended to stimulate active learning.
4. The measurement of students creativity can be evaluated through learning outcome. (Mayer, 1989)

Briefly, these are the creativity training goals:
1. Raising creativity consciousness and creative attitudes in the students.
2. Improving students' metacognitive understanding of creativity.
3. Strengthening creative abilities through exercise.
4. Teaching creative thinking techniques.
5. Involving students in creative activities. (Davis, 1988)

The misconception that creativity is present only in the fine arts is unfounded. Creativity is apparent in every facet of human activity. (Davis, 1989) Dr. Fad agrees, yet further stresses that fairly loose structure is ideal for specific environment and activity that can stimulate the inventive thinking processes. There is no reason why something can't be "inside out or upside down." (Hakuta, 1988) The environment should not limit children, regardless of standards. He also pointed out that standards should not be rigid but should be pliable to encourage creativity. The Dr. Fad show encourages invention for both fun and important ideas and emphasizes that the best student and the average student can be creative and inventive. (Hakuta, 1988) The need to remove the rigidness from the classroom is best summarized by Mark Runco, "We put children in groups and make them sit in desks and raise their hands before they talk. We put all the emphasis on conformity and order, then we wonder why they aren't being spontaneous and creative." (Dormen and Edidin, 1989)

Children should be encouraged to be creative with computers since it is the wave of the future. Today, when the average child reaches five, they have already spent about 5,000 hours of their free time watching television. (Wassermann, 1989) Presently, computer games have taken over the free-time activities rather than active play and hobbies. Budget restraints in most schools have contributed to their dropping music and art programs to allow for the purchase of new computers. Some educators criticize the inability of computers to

nurture students' imagination; however, computer-based learning technologies can be used creatively in all curricular areas. That is, by combining traditional basic skills (reading, writing and mathematics), the creative process, and computer technology, one can interrelate and facilitate a more imaginative problem-solving technique. The computer can be considered a high technological expressive medium like words, paint, and clay. (Adams and Hamm, 1989) The computer's flexibility permits the imagination to choose and combine elements on various levels. For example, computer graphics, numbers, words and music can be generated through the use of visual models manipulated. Since students can learn more about creativity from failures and mistakes, children need to learn that taking risks, making mistakes, and debugging the programs are a part of computing and a part of creative growth. (Adams and Hamm, 1989)

Personality/biographical inventories and divergent thinking tests are examples of actual testing for creativity. However, these types of tests are not reliable. Personality/biographical inventories evaluate attitude, awareness, motivation, values, interests, hobbies and histories of creative activities. This type test is based upon studies of the personality and biographical backgrounds of creative people.

In order to understand divergent thinking tests, divergent thinking should be explained. It is a mental activity where there is not a concrete answer or solution. Divergent thinking is the opposite of convergent thinking, in which there is concrete answer or solution. (Ripple, 1989) A classic example of a divergent test is asking the class to find uses for a brick through a process known as group brainstorming. In group brainstorming children can build upon one another's ideas resulting in more innovative solutions. The Torrence Test of Creative Thinking falls into the category of divergent thinking tests. This test evaluates critical underlying cognitive abilities, and it is scored by flexibility (producing many unusual ideas), fluency (producing many ideas), originality (producing unique ideas) and elaboration (adding detail to the ideas). In Brazil, students remain in school for a short period of time. Most Brazilian teachers recognize the positive changes in both teaching approaches and perceptions of their students. After participating in a creativity program for educators, some of these teachers who studied the Torrence Tests of Creative Thinking (1974) improved their scores in several creativity measures. (Soriano de Alencar, 1989)

Educators have to encourage, stimulate imagination, and evaluate creative learning in the classroom. They should find something positive in a student's idea. By systematically rewarding creativity in students, the instructor entices students to be more creative in their efforts. Since evaluating creativity is subjective judgment, it should be rewarded in the form of extra credit. (Glover and Bruning, 1990)

A basic understanding of the definitions of creativity and of ordinary creativity plus a knowledge of the qualities of a creative person are needed before enhancement of creativity can be achieved in the classroom. By discussing the evolution of periods of creative growth, a better overview of students' creative expectations at their respective years should evolve. Studies have shown that it is critical to stress creativity in the early years (ages 0-5) so that it will accelerate with age. The need for microneuron and right brain research is evident for a better understanding of creative growth. After a comprehensive study of all aspects of creativity, creative teaching takes place when the student absorbs the knowledge and relates it to imaginative problem solving. Better creative problem solving comes with emphasizing divergent thinking to the students. Combining basic skills, traditional creativity and computer technology can interrelate and facilitate the creative atmosphere for problem solving. Evaluation for creativity is difficult to assess. Since standardized creativity tests are not reliable, teachers must resort to formulating their own assessment of creativity by providing a relaxed creative atmosphere, by demanding creativity from students, and by systematically rewarding creativity.

Finally, instructors are the best models of creativity for students. One psychologist, McGrath, predicts that creativity will be "the survival skill of the 90s." (Dormen and Edidin, 1989) But Torrence (1974) said it best: "people can be creative in an infinite number of ways." These quotes sum up the message that needs to be conveyed by educators. Students should possess the abilities and aptitude to solve everyday problems with ingenuity, flexibility and spontaneity.

Conclusion

Creativity is not for a selected group of people; it is widespread among students. Through modeling and planned creative activities, teachers can facilitate creative expression.

A Teacher's View
of Creativity in the Classroom

A teacher who keeps in mind that creativity is an accepting attitude rather than a lesson to be interjected here and there in the dictated curriculum will have a creative class. Most teachers feel that creativity must be taught in art or music and that content areas are to be standardized and rigid. Many teachers doubt their own creativity and are afraid that if children are given any freedom, the control in the class will be lost. There is a difference between giving the children control over their own class and providing a risk-free and safe environment in which the children feel comfortable enough to experiment within reasonable bounds. A child who graduates from school with good grades because he has learned how to give back what was given him but develops no self-confidence in his own ability to solve problems, evaluate, and reach workable conclusions will not be a creative individual and will not function as well as the child who has combined mastery of content area and confidence in his own ability to reach the "right" conclusions when faced with different situations.

Providing an Environment for Creativity

Providing a creative environment in the classroom takes a lot of planning and constant reevaluation. Of course, much of a teacher's day is dictated by mandated curriculum and directions over material that must be covered during the course of the academic year, but in areas where they could have some choice, the teacher will have more cooperation from fellow planners. The more opportunities children have to make choices, the better their choices will be, and the more daring they will be to try new things without fear of failure.

Classroom organization and management should be planned with the whole child in mind. The social, emotional, physical, and intellectual needs of each child should be considered when activities and lesson plans are designed. The teacher will need a working knowledge of the stages children go through in each of these areas

and plan accordingly. Creativity in the classroom comes when children see relevance in what they are exposed to and are allowed to experiment and utilize what they have learned.

Creativity is hard to define, but easy to recognize. It is much easier to stifle than to encourage. It is a way of thinking and reacting that needs constant reinforcing. It involves fluency, flexibility, elaboration, originality, evaluation, and an element of freedom. These things may be threatening to some teachers. It is certainly easier to do exactly what the text says to do, to follow rigid lesson plans that allow for no deviations or choices. Creativity is as stimulating for the teacher as it is for the class. Constant evaluation, reassessment, and modification keeps the teacher enthusiastic and enthusiasm is contagious. Teachers who teach by example, who allow their students to see them experiment, try new things, fail, and succeed will stimulate the same activities in their students.

Research observes that creativity can be taught or allowed to grow in a safe, risk-free environment. This environment can exist in any classroom to some degree, in any subject or content area, and can be illustrated by any teacher who is not afraid to learn from his or her students. "Creative teaching and learning" takes a lot of planning, a special kind of control, and a teacher who is not afraid to take a chance and accept new ideas—to step beyond the text.

Every minute of the school day seems to be budgeted to meet state curriculum demands or dictates from the school board, administrators, community, etc., and teachers sometimes feel that they have to "take a day off" to have a creative activity. Not so. Children can be allowed a certain amount of freedom and creativity in any subject matter, in any lesson, and still stay within the limits of the specified curriculum. Simply creating an atmosphere, using lots of "what if" questions, allowing children time to themselves, and permitting more than one "right" answer or one "right" method of finding it can foster creativity in the student.

Creativity—A Way of Thinking and Doing

Creativity is a way of thinking and doing. It is an attitude and an ability to recognize valuable innovations. Creativity is not the same as intelligence, but research indicates that creative thinking con-

tributes to increased success in school because it allows for a variety of interests and a variety of ways to approach subject matter. Creativity involves fluency, flexibility, originality, elaboration, individuality, awareness, and evaluation.

"Discovery consists of seeing what everybody else has seen, and thinking what no one else has thought." ("Discovering the Magic," Nancy L. Johnson, *Challenge*, November–December 1986.) It is a technique for problem approaching and problem solving. Children come to school with a certain amount of creativity already inside them. Depending upon their genetics, natural curiosity, self-esteem, home attitude and acceptance, and previous school experiences, children can be allowed to further grow in this area or forced to conform to finding the one "right" way of doing something. Sometimes teaching following the rules, always being practical, and always finding the right answer by the right method can be a real block to creative thinking.

Because our environment is constantly changing, children need to be prepared to survive and grow to live effectively in such a world. Children function as a planning, thinking, doing, and assessing individuals, and allowing children to be creative within the school setting promotes independence, self-confidence, and an ability to problem solve. All areas of the curriculum can be approached in an accepting, risk-free manner without jeopardizing the necessary concepts taught. Children who can't seem to find the "right" answer using the only manner taught will not feel good or be successful in meeting the challenges life will put before them.

Creativity—
Evaluation of Teachers and Program

Evaluation of creativity may be achieved in two phases as outlined below.

Phase I: Formative Evaluation

Teachers. We must move very cautiously in the area of evaluation. The first thing children learn about being human is that it requires courage. We have asked them to confront their experience honestly, to reflect on its meaning and value. This takes courage, which is recognized in their ability to live through the art practice. The teacher can evaluate courage in a child according to the child's ability to identify real concerns and willingness to take chances, to speculate about meanings, to explore new realms of expression, to risk failure and be ready to try again. It is the willingness to undertake a personal search in order to make a personal discovery.

In addition to courage, children should learn that being human requires making decisions. They have to adopt the habit of making rational and intuitive choices among the alternatives presented by the tasks they have helped to select. Following directions about what to do and how to do it will result in a more orderly class and more guaranteed "creative" products. A child's ability in decision-making will be visible to some extent in the way he or she opens up options during the stage of expansion. If the child is reluctant to explore the meanings of a problem, it is because many alternatives of choice are frightening. Thus, there is a tendency to simplify decision-making by limiting intellectual and creative opinions.

The crucial test of a child's decision-making, however, is the quality of creative effort. There can be no value in courage or in decision-making unless contingent character is recognized by teachers and pupils alike.

From the standpoint of evaluation, how do you take a presentation or creative effort seriously? First, pay attention to it, rather

than collect or store it. Second, interpret the presentation to children in terms of the quality of the decisions it represents. That is, the teacher publicly examines what children have made or presented to the class by describing or explicating the connections between what the class has seen and the creative problems the children have tried to solve. This calls for a sensitive and perceptive response to what the child has done. This phase of the total evaluation process should take place as soon after each presentation as possible. It may be argued that there is not enough class time to perform such an evaluation, but the problem arises only if we encourage children to make more products than we can properly attend to. In other words, we may be trying to avoid evaluation by completely filling the class time with forming activity; as a result we convert the classroom into a cottage industry for the fabrication of products. (Jones, 1982)

Beyond courage and decision there is appreciation, or the capacity to accept and understand what another person has accomplished. Appreciation is a creative and imaginative act—not merely an expression of passivity or tact in a social situation. Some children are gifted appreciators and all children should be given opportunity in the classroom to demonstrate powers of visual discrimination and interpretation.

Revise Instruction Based on Results

An important function of formative evaluation in the classroom involves the systematic collection of data in order to revise instruction while it is still in the developmental stages. In this context, formative evaluation can be characterized as a process of "trying out" specific instructional procedures, materials, or curricula in order that they might be improved through systematic evaluation procedures. Our curriculum on creativity focuses on this aspect.

Teachers typically plan instruction on a daily or weekly basis. Once instruction has been planned and implemented, little attention is given to how a particular instructional sequence might have been improved. In the past, instructional evaluation has been confined primarily to grading student worksheets or tests. Evaluation of student worksheets and tests does provide important information to the student and to the teacher, but this information is seldom used for the

revision of specific instructional units or lessons. Teacher-made tests and quizzes are to some degree formative instruments, but they are usually employed to measure the success of students rather than the success of instruction. Only rarely does a teacher use test data as a basis for revising or modifying instruction.

The point stressed here is that often the brunt of the responsibility for learning falls directly on the student and is not shared equally by the teacher. If the teacher provides instruction that is inappropriate for the student, presents inaccurate information, or teaches a specific lesson out of sequence, the result may very well be student failure. By not following a systematic process of instructional revision, teachers may cause students to have difficulty with the instruction—not because the students are incapable of learning, but because the instruction fails to teach.

Phase II: Summative Evaluation

Program. Scriven (1967) has emphasized that no study of any program can be labeled as evaluation unless some judgment is made. In other words, values as standards are a central consideration in evaluation studies. Furthermore, the distinction between formative evaluation (evaluation used to improve a program while it is still fluid by providing feedback to the developer) and summative evaluation (end product) is crucial to any school or school system.

Summative evaluation is achieved by looking at the results. In other words, is the end product—that is, the student—changed in ways that were hoped and anticipated? This, after all, is what teaching and learning are all about.

Pre and Post Assessment

To be completed by the participants at the beginning and at the end of the series of workshops.

Self-Evaluation

Is My Creative Program a Multicolored Thing?
Color Code:
1) No, color all squares black.
2) Some, color any two squares green.
3) Most of the time, color three squares red.
4) All of the time, color three squares blue.
5) All this and more, color squares multicolored.

- Do I realize that each individual does create? ☐ ☐ ☐

- Do I encourage children to be more alert perceptually in their reactions to their world of experience? ☐ ☐ ☐

- Do I motivate children to explore new ideas, to be original in their thoughts, to dream about new possibilites and to imagine and pretend? ☐ ☐ ☐

- Do I motivate students to investigate the nature of things, to seek facts and knowledge, to discover new relationships and transform them into their own products? ☐ ☐ ☐

- Do I lead children to discover and to be sensitive to aesthetic stimuli in both usual and unusual places? ☐ ☐ ☐

- Do I give lively animated surefire demonstrations in relation to techniques and procedures? (This should include smiling.) ☐ ☐ ☐

- Do I keep children's development levels in mind when planning lessons, so that they are neither bored nor frustrated? ☐ ☐ ☐

- Do I love to teach creatively (not just on Friday afternoon)? ☐ ☐ ☐

- Do I encourage children to apply divergent thinking to standard materials as well as junk materials? ☐ ☐ ☐

- Do I analyze sensory perceptions in detail and teach chlidren how to perceive many details of one object or experience and encourage them to synthesize details into unique configurations? ☐ ☐ ☐

- Do I successfully motivate the child for an expressive experience and assist him or her in creating an aesthetic expression? ☐ ☐ ☐

- Do I praise my fellow teachers who provide creative experiences for their children? ☐ ☐ ☐

- Do I schedule at least three periods each week for creativity? ☐ ☐ ☐

- Do I have examples in my room to illustrate our heritage and to provide motivation for future works? ☐ ☐ ☐

- Do I have an adequate way to dispense supplies in the classroom so that I am not discouraged from using certain materials such as clay, poster paints, or plaster? ☐ ☐ ☐

- Do I arrange my room to make production easy? ☐ ☐ ☐

- Do I value my teaching as a worthwhile experience for all children and project this attitude during my lessons? ☐ ☐ ☐

(Adapted from: *Developing Artistic and Perceptual Awareness,* pp. 158–160)

Scope and Sequence Chart

This manual can be implemented in four unique time frames:

	Option A 5 8-hour workshops	Option B 10 4-hour classes	Option C 20 2-hour classes	Option D Variable Inservice
Workshop I	1 session	2 class sessions	5 class sessions	flexible
Workshop II	2 sessions	3 class sessions	5 class sessions	flexible
Workshop III	1 session	3 class sessions	5 class sessions	flexible
Workshop IV	1 session	2 class sessions	5 class sessions	flexible
Total hours	40	40	40	flexible

Workshop 1
Development Theory

At the completion of this workshop, each person will design objectives and materials, in accordance with their students' developmental levels.

Objectives

A. Each teacher will attend presentation on development theory of child development. At the end of each level, the teacher will write a list of five benefits of thinking through development in the classroom organization.
B. Each teacher will write a 20-minute lesson by the end of the third week of school. This lesson will be based on the level of students they are teaching and identifying what level operations the lesson is geared based on Piaget developmental levels.
C. Using text as a guide, teachers will design a 20-minute activity by the end of the fourth week based on the physical characteristics of the students under their responsibility.

Suggested Workshop Procedures for Facilitators

This workshop focuses on the theoretical bases for enhancing creativity in the classroom.

Begin your preparation for the workshop by reading thoroughly all the procedures and content in this book. Some of the assignments require that you work out appropriate timing in order to implement them effectively.

Begin this session by lecturing on the purposes of the workshop and by explaining the key concepts related to creativity as included in the Introduction and in the article "A Teacher's View of Creativity in the Classroom." Prepare an outline to be displayed on the chalkboard or on an overhead projector. An example of your outline may be as follows:

A. Creativity is often neglected in favor of conformity.
B. Creative is widespread; if allowed to evolve, it will do so.
C. Creative expression requires a base of knowledge; but knowledge alone does not guarantee that creativity will be expressed.
D. Teachers can facilitate creativity both through modeling and through the activities they plan in the classroom.
E. Creativity can be expressed in a wide variety of ways; it is the implementation of a way of thinking.

Following the lecture, divide the participants into small discussion groups of three to five persons. Ask them to discuss the following questions and prepare a report on their answers.

1. How do you define creativity?
2. What factors contribute to creative expression in the classroom?
3. What factors hinder creative expression in the classroom?

Continue by asking the participants to complete the self-evaluation instrument on pages 19–20. You will need to provide multicolored pencils for them to use. Then lead in a discussion of how they scored the instrument by asking:

1. How did you rate yourself on the various items?
2. What color appears most? What color appears least?
3. What changes would you like to make in how you scored?

Make and display on an overhead projector a copy of "Piaget's Developmental Stages." Using the display, briefly explain each developmental stage. Ask, "How does Piaget's research impact teachers as they plan classroom activities? How can teachers implement this research into their teaching?"

Ask the participants to study the Developmental Information contained on pages 35–37. Ask them to (1) identify the age group which they teach and (2) report three behaviors they have recently observed in children that are consistent with this developmental information.

Divide the participants into small study groups of three to five persons. Ask them to look over the "Hierarchy of Creative Skills" on pages 39–42 and brainstorm ways they might help children to move upward in the hierarchy of skills.

Display before the participants a chart of Maslow's "Hierarchy of Needs." Explain that these needs motivate all of us, teachers as well as students. After explaining the hierarchy, ask, What behaviors might a child exhibit in attempting to meet the needs described in the five levels of the hierarchy?

Finally, study the objectives for this workshop listed on page 24.

Make assignments to participants as outlined in the objectives.

Theories of Children's Art

Any theory of art has to account for the fact that children's drawings do not closely resemble what we see. And this problem raises many questions. Does child art or other works resemble what children see? Does child art reflect difficulties in handling materials such as crayons and paint? Does it reflect incomplete neuromuscular development and coordination? Does child art reflect immature powers of thinking and knowing? Do a child's sensory perceptions explain his forms of representation? Are his representational efforts always adequate for his intentions or for the content of his perceptions? And finally, is it certain that children attempt to represent their optical experience? Perhaps they prefer to invent forms which they afterward claim are replications of what is out there to see. (Feldman, 1970) The above questions transcend all content and grade levels.

These are some of the fundamental questions that theories of child art try to answer. You can see that psychologists and others interested in the nature of human thinking and perceiving find these questions fascinating. Aestheticians and philosophers of art are also concerned, because insight into the nature of child art activity would presumably throw light on the work of mature artists.

The educator is concerned with these questions because of interest in the systematic growth of school children and in the normal parameters of child behavior; if the child's perceiving, thinking, feeling, and representational activity can be understood, perhaps that understanding can be applied for the purpose of deliberately organizing teaching and learning, and can influence creativity.

Cognitive Theories

Cognitive, or intellectual, theories of art are best described in the common observation that a child draws or represents what "he knows" rather than what he or she sees. Distortions of size and shape in a child's art are presumably due to lack of knowledge or inadequate concept development about the "correct" or "real" sizes and shapes of things. It is assumed that correct knowledge about reality is the

basis of the accurate representations of reality in art. Increased experience with the world will enable the child to modify his faulty or inadequate early conceptions of things so that they are brought more into line with objective reality. According to such theories, the child's eyesight is as good as that of a healthy adult, and motor control is not a serious handicap in the representation of the child's experience. In other words, there is no optical or physiological reason for this distortion or oversimplification in artistic representation. The child's retinal images are the same as an adult's. But in the act of representing what he or she sees or recalls, the child does not trust his or her sense data, remembering or thinking mainly about the name of what is being represented. The child responds only to an intellectual or conceptual understanding of objects—an understanding which is, of course, defective because of the child's relative unfamiliarity with the real world and the things in it. As the child learns and matures, he or she will build more and richer concepts for dealing with his or her experience. These richer concepts will find expression in his or her art, in more detailed, complex, and accurate imagery.

For young children, especially, immediate sensations are of vital importance for artistic expression. Consequently, their preference for circles in the representation of people and things may appear to be a departure from their sense data. Cognitive theorists believe these circles are representations of intellectual concepts—in other words, abstractions. But this preference cannot be understood as a precocious ability to create abstractions and symbols instead of visual limitations of what the child sees. Visual imitation is the child's intent, not optical imitation of the qualities of things seen. The simple circles and straight lines constitute the best graphic representation children can make of their perceptions. Conversely, abstraction and symbol-making are very advanced types of expression; much too advanced for the lower-elementary school child. In the history of art, Neolithic abstraction follows Paleolithic naturalism. In primitive states of awareness (such as that of small children), the impact of sensation has the highest claim on consciousness. The child's problem is to manage these sensations in the form of a representational device. And the circular and straight line forms are the best solution children can achieve. The fact that they predominate in the early art of children cannot, therefore, be explained as the possession by children of common concepts or generalizations about the shapes of things. They

constitute common ways of organizing and representing visual perceptions.

Developmental Theory

From empirical study of many children's drawings it is possible to identify distinct changes in modes of representation as the individual grows older. Beginning with scribbles during the nursery and preschool years, a child moves on to the use of circular, ovoid, and stick-like representations of people and things; to the creation and repetitions of basic representational formulas that seem to the child adequate during the lower elementary grades; to the gradual addition of detail to the basic formula, including representations of space and motion; to increasing degrees of visual correspondence to the shape, color, and spatial location of objects during the upper elementary years; and to a proximal if awkward realism at about the time of puberty. These changes in artistic expression have been identified as stages of growth accompanied by development in a variety of other dimensions, notably in the work of the late Victor Lowenfield (1947). He maintained that changes in visual expression correspond to intellectual, emotional, social, perceptual, physical, aesthetic, and creative changes within the child. He names the artistic stages and the ages of children typically going through them as follows:

Scribbling stages	2 to 4 years
Preschematic stages	4 to 7 years
Schematic stage	7 to 9 years
Dawning realism	9 to 11 years
Pseudorealistic stage	11 to 13 years

It is clear that by connecting so many modes of growth and development to each type of representation, Lowenfield attributed enormous importance to the change from stage to stage of artistic development. Other developmental theorists may differ about the precise chronological ages of children during each stage. But there is general agreement that children draw approximately the way they are "supposed to" in Lowenfield's typology. More serious disagreement centers on the influence of instruction or other forms of external

stimulation in the determination of the child's imagery. Lowenfield realized that all children do not uniformly enter and pass through each stage of artistic development. He did, however, seem to regard the stages as norms, so that very wide discrepancies between chronological age and a child's developmental stage in art would suggest some mental or emotional difficulty, if not retardation. If a child persisted in repeating an early (that is early for his or her stage of development) representational formula or stereotype, some emotional, social, physical, intellectual, creative, or other type of maladjustment was indicated.

What, according to developmental theory, causes a child to move from stage to stage of artistic expression? Lowenfield seems to have believed that it was mainly change of affective relationships to people and things in the environment. The size of objects in a drawing, for example, is determined by their importance to the child rather than their actual bulk. this view can be seen as a variation of the cognitive view that concept development is tied to artistic development. Presumably the child's concept of his or her mother would make the child draw her larger than his or her father, because the idea of the mother is more important than the idea of the father. However, Lowenfield contended that artistic expression could govern, or at least strongly influence, concept development: a child's concept of mother or father may originate in many kinds of interaction with them; but through appropriate types of stimulation and motivation resulting in artistic representation, the child's concept of his or her parents could be changed. By changing size relationships in drawings of persons, for example, the child can be induced to change the way he or she thinks about them because importance, for the child, is represented by size.

Gestalt Theory

The fundamental position of Gestalt theorists is that we do not see objects as the sum of directly observed parts; we see perceptual wholes, or total images structured by the brain on the basis of retinal impressions and the basic requirements of the perceiving organism.

Accordingly, the child's early representations are not symbols invented through mental processes of abstraction; that is, through

eliminating what is (to the child) unessential detail. (Obviously to do this their child would have to possess a Platonic idea about the "essence" of the object being represented.)

Conclusion

Each of the theories of child art presented here so briefly is, to some extent, plausible. Despite flaws of one sort or another, each theory offers a reasonable convincing explanation of some aspect of the phenomenon of child art. But, as teachers, we are naturally interested in their implications for classroom practice. Here we encounter a serious difficulty, as with all theory, not in the adequacy of the theories for explaining child art, but in the nature of their relevance to the practice of art education. The reason for the difficulty is clear: any theory of child art describes what happens when children create their typical imagery; but art education needs to foster human development through the art children see and study as well as the art they create. Even if child art could be completely explained, the questions would still remain: What does this have to do with the education of children through art so that they will become complete human beings? The fact is that a total program of art education cannot be built on the foundation of theories of child art alone.

It is easy to confuse the "is" of theoretical investigation with the "ought" of educational practice and morality. The fact that children normally create artistic imagery of a certain type, at a certain stage of their development, does not mean that the art education curriculum should be mainly devoted to encouraging the production of such images. It only means that children need the opportunity to paint and draw and model and build. It is also clear that the connection of a child's art with any social or personal difficulty he or she may have is demonstrable but really outside the province of art education. The most serious error we make in building art education curricula on admittedly sound theories of child art emerges in the isolation of the child's imagemaking from the social and human matrix of artistic creation. In other words, we do not give children good reasons to make art.

Because of a convincing theory of child art, a teacher may be persuaded to entrap children into creating images because it is

supposed to be good for them. In practice, we often force children to create art in the absence of any compelling reason of their own to do so. The work that emerges may reflect the characteristic imagery of children but it rarely reflects an authentic, a genuinely felt, occasion for artistic expression. As a result, children use materials and create images under the auspices of the elementary school largely because they have to.

What conclusions can we draw from these remarks about the theory of child art and its connection to art education as a whole? First, we must recognize that child art is the inevitable rather than the forced product of normal human development. Second, we have to understand the creation of imagery by children as being natural in the context of their needs but to necessarily of ours. Third, we must not entrap children into creating art so that we can use their imagery for purposes of diagnosis or mental measurement. Fourth, we have to design curricula in which the creation of art is one of the outcomes of a teaching practice rather than its sole objective.

Intellectual Development Stages from the Writings of Jean Piaget

Development Stage	General Age Range	Characteristics of Stage Pertaining to Problem-Solving, Comments and Examples
Sensory/Motor	Birth to approximately 18 months	• Stage is preverbal • An object "exists" only when in the perceptual field of the child • Hidden objects are located through random physical searching • Practical basic knowledge is developed which forms the substructure of later representational knowledge
Preoperational or Representational	18 months to 7–8 years	• Stage marks the beginning of organized language and symbolic function, and, as a result, thought and representation develop • The child is perceptually oriented, does not use logical thinking, and therefore cannot reason by implication • The child is simple goal–directed, activity includes crude trial-and-error calculations • The child lacks the ability to coordinate variables, has difficulty in realizing that an object has several properties, and is commonly satisfied with multiple and contradictory formulations • Since the concept of conversation is not yet developed, the child lacks operational reversibility in thought and action

Concrete Operations	7–8 years to 11–12 years	• Thinking is concrete rather than abstract, but the child can now perform elementary logical operations and make elementary groupings of classes and relations (e.g. serial ordering) • The concepts of conversation develop (first of number then of substance, of length, of area, of weight, and finally of volume) • The concept of reversibility develops • The child is unable to isolate variables and proceeds from step to step in thinking without relating each link to all others
Propositional or "Formal"	11–12 years to 14–15 years	• Stage of formal (abstract) thought marked by the appearance of hypothetical-deductive reasoning based upon the logic of all possible combinations; the development of a combinatorial system and unification of operations into a structured whole • The development of the ability to perform controlled experimentation, setting all factors "equal" but one variable (at 11–12 years to 14–15 years, the child's formal logic is superior to his experimental capacity). Individuals discover that a particular factor can be eliminated to analyze its role, or the roles of associated factors • Reversal of direction between reality and possibility (variables are hypothesized before experimentation). Individuals discover that factors can be separated by neutralization as well as by exclusion
	14–15 years and onward	• The individual can use interprositional operations, combining propositions by conjunction, disjunction, negation, and implication (all arise in the course of experimental implications)

Developmental Information

The Five Year Old – K

Physical Characteristics

A. Period of slow growth
 Motor skills are unevenly developed.
 Marked development in large muscles.
 Small muscles and eye-hand coordination not well developed.
B. Appearance
 37 to 45 inches in height; weight about 35-45 pounds.
 Girls usually ahead of boys in physiological development.
C. Interest
 1. Playground equipment, working with large blocks, tempera and clay (which all help in developing a readiness for handwriting).
 2. Likes hammers and saws for physical activity.
 3. Skating, skipping, marching, hopping to music
 4. Interested in using new and unusual sounding words.

Emotional Aspects

A. Sometimes referred to as "The Perfect Age"
B. Normally well-adjusted
C. Likes approval although does not demand praise
D. Enjoys possessions
E. Is serious, business-like, realistic, and well-poised
F. Great talker
G. Self-centered (I, me, mine)

Social Development

A. Parallel Play comes before Cooperative Play
B. Likes small group play
C. Recognizes ideas and tells ideas, and is becoming aware that communication takes place through writing

The Six Year Old – 1

Physical Characteristics

A. Body lengthens
B. Feet grow larger
C. Heart is in a period of rapid growth
D. Eye-hand coordination is improving steadily
E. Needs opportunity for running and jumping to develop muscles
F. Baby teeth are being replaced with permanent ones

Emotional Aspects

A. Jealous
B. Feels unloved and unwanted
C. Becomes discouraged easily
D. Worries about sex
E. Fears the dark, thunder, doctors, illness, and pain
F. Negative in his response to others

Social Development

A. May have difficulty playing amicably with other children
B. Demanding
C. Wants privacy
D. Needs to achieve
E. Concerned with right and wrong
F. Likes to give and receive gifts

The Seven Year Old – 2

Physical Characteristics

A. Full of energy but easily tired
B. Becoming more cautious in doing new things
C. Repeats performance to master it
D. Posture more tensed, maintained for longer periods of time
E. Eyes not ready for near work
F. Likes to use hands
G. Disease susceptibility high
H. Needs varied physical activities

Emotional Aspects

A. Becoming more of an introvert
B. Lengthening periods of calmness and self-absorption
C. Good listener
D. Resents intrusions on day dreams. Feels ill at ease if he/she didn't finish them

Hierarchy of Creative Skills

This theoretical hierarchy of creative thinking skills is given to teachers for guidance in the arrangement and sequencing of activities for their individual classrooms. Teachers will pick a skill or skills appropriate to their students and include in objectives and implementation of art lessons. Systematically including these skills as objectives will help promote growth in creative thinking skills in a structured fashion.

Level 1

1. The child will be able to produce new combinations through manipulation.
2. The child will be able to see and produce many possible combinations or new relationships.
3. The child will be able to identify missing elements in pictures, shapes, letters, and so forth at a very gross level.

Level 2

1. The child will be able to produce increasingly more complex new combinations through manipulation and move to more deliberate experimentation.
2. The child will be able to see and produce increasingly larger numbers of possibilities in combining symbols, objects, numerals, people, places, and so forth.
3. The child will increase his verbal fluency by naming new combinations of shapes, sounds, movement, animals, people, and so forth at a simple level.
4. The child will be able to make simple syntheses by giving titles or labels to pictures, stories, songs, poems, creative dances, puppet plays, complex wood sculptures, and so on.

5. The child will improve his skills in asking questions about missing elements in objects, pictures, and so forth.

Level 3

1. The child will continue to improve his skills in asking questions about missing elements in pictures, stories, creative dramatics, and so forth.
2. The child will be able to identify missing elements at an increasingly complex level and to check discrepancies.
3. The child will be able to order sequences of events in cartoons, photographs, and the like.
4. The child will begin developing skills of empathy (imagining himself in the role of another being and going beyond egocentric concerns).
5. The child will be able to recount the sequence in the creative problem-solving process.
6. The child will accept limitations creatively rather than cynically or passively.

Level 4

1. The child will develop increasingly higher level skills of producing new combinations of things and people in places.
2. The child will become aware of more complex combinations of sounds and will produce new combinations himself.
3. The child will develop increased tactual sensitivity.
4. The child will be able to produce a variety of ideas about possible functions or uses of animals, machines, etc.
5. The child will be able to produce alternate possible consequences of new combinations of objects, people, places, and actions.
6. The child will increase his skills in empathy.
7. The child will increase his willingness to attempt difficult tasks.

8. The child will be able to make easy, simple predictions from limited information.
9. The child will develop increased skill in using his imagination in seeing and hearing things at different distances.
10. The child will extend his skills in asking questions about pictures and stories
11. The child will produce alternative endings for stories.

Level 5

1. The child will be able to produce and play with analogies.
2. The child will continue developing his ability to produce alternative possible consequences.
3. The child will begin to develop ability to produce alternative causes of behavior.
4. The child will continue to produce alternative solutions to problems.
5. The child will continue developing skills of empathy.
6. The child will continue developing his ability to elaborate.
7. The child will continue developing his ability to visualize.
8. The child will begin producing unusual and novel ideas.
9. The child will begin developing ability to synthesize diverse elements.
10. The child will continue developing his forecasting ability.
11. The child will continue developing his ability to imagine feelings.

Level 6

1. The child will continue developing his ability to infer causes and consequences of an increasing variety of behavior.
2. The child will go beyond the obvious, superficial, and commonplace and infer meanings from statements in stories, descriptions of events, and the like.

3. The child will begin to acquire real skills in elaborating ideas--working out the details of ideas, building up an image, and filling in gaps in information.
4. The child will begin making real progress in learning skills of empathy.
5. The child will begin making real progress in developing question-asking skills.
6. The child will be able, with guidance, to carry through the sequence of creative problem solving.
7. The child will advance his skills in differentiating guesses or hypotheses from conclusions.
8. The child will make further progress in developing skills of synthesizing diverse elements.
9. The child will continue the development of his ability to visualize objects, places, actions, people, and so forth.
10. The child will continue the development of his ability to write original stories and poems.
11. The child will produce alternative ideas about the relevance or application of a particular story.
12. The child will build into his existing knowledge by relating ideas in a new story to other ideas.
13. The child will increase his understanding and appreciation of his curiosity. (Torrance, 1970)

Maslow's "Hierarchy of Needs" Theory of Human Motivation

	Needs	Physiological and Psychological Indicators
Higher-level needs	**Level 5** Self-Actualization or Self-Fulfillment	• Achievement of potential • Maximum self-development, creativity, and self-expression
	Level 4 Esteem	• Self-respect—achievement, competence, and confidence • Deserved respect of others—status, recognition, dignity, and appreciation
	Level 3 Belonging, Love, and Social Activity	• Satisfactory associations with others • Belonging to groups • Giving and receiving freindship and affection
Lower-level needs	**Level 2** Safety and Security	• Protection against danger threat • Freedom from fear, anxiety, and chaos • Need for structure, order
	Level 1 Physiological Needs	• Hunger • Smell • Thirst • Touch • Sex • Sleep • Taste

Workshop 1
Notes and Reactions

45

Workshop 2
Creative Thinking Skills

At the completion of Workshop Two, teachers will develop teaching methods that promote the development of students' perceptual awareness and creative thinking skills.

Objectives

A. Each teacher will construct an "awareness book" to be handed in at the third workshop consisting of personal checklists on the following: (1) experiencing details, (2) experiences, (3) empathy or identification, (4) sensory discovery along with a paragraph on his or her personal concept of awareness. For checklists see Appendix II-B (Evaluation—completion of checklists and written paragraph on awareness will show completion of objective).

B. Each teacher will design and implement four perceptual awareness activities (one per week) for his or her classroom. The teachers will submit lesson plans for these activities during the second workshop. See examples and guidelines (Evaluation—completion of four written lesson plans of awareness activities based on guidelines and examples will show completion of objective).

C. Given a theoretical model of hierarchal creative thinking skills along with examples for developing art lesson plans, each teacher will write four art lesson plans (to be handed in during third workshop) incorporating activities that promote creative thinking skills appropriate to his or her students' developmental level. Teachers will present one of these plans for discussion in small group sessions during the third workshop. See model and examples for planning (Evaluation—completion of four written lesson plans incorporating creative thinking skill(s) will show completion of objective).

D. Utilizing the lesson plan guidelines and model for creative thinking skills given, each teacher will design one art lesson that will be demonstrated during one of the last two workshops. (Evaluation—group presentation of art lesson incorporating creative thinking skill(s) will show completion of objective.)

E. Each teacher will write four art lessons following the guidelines and model. (Evaluation—completion of four art lesson plans following guidelines and model will show completion of objective.)

F. Each teacher will be cognizant of various teaching strategies.

Suggested Workshop Procedures for Facilitators

Call for reports on the assignments made from the previous workshop.

This workshop focuses on classroom environmental factors that contribute to creative thinking.

Begin this session by displaying a poster as illustrated:

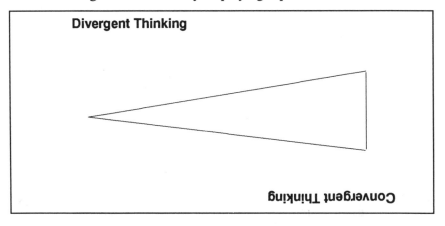

Hold the poster in the appropriate way so "Divergent Thinking" can be read. Then reverse the angle of poster so the participants can read "Convergent Thinking." Ask, "What is the difference?" (Creative thinking is divergent). State that this workshop will focus on divergent or creative thinking.

On the chalkboard, write:

Creative thinking skills are encouraged by:
Appropriate Classroom Atmosphere.
Low Risk Environment.
Increased Awareness of Sensory Experiences

Provide each participant with an 8 1/2 X 11 sheet of paper on which a "classroom area" is drawn in the form of a rectangle as illustrated.

Ask the participants to use the information on pages 55–56, "Creating an Atmosphere for Creative Thinking," to design a classroom. The purpose is to arrange the classroom appropriately, not to create good art. After each individual creates the classroom, divide them into small groups of three to five participants and ask them to share what they have created. Also ask them to evaluate their classroom design, using the criteria in the "Checklist for Objective B" (see p. 58).

To help the participants to experience the meaning and value of a sociogram, divide the participants into small groups of five members each. Appoint a observer/recorder for each group. The observer/reporter's task will be to construct a sociogram of the group as they discuss the following questions:

1. What kinds of teacher behaviors contribute to creative thinking?
2. What kinds of teacher behaviors hinder creative thinking?

Allow 10 minutes for discussion. Then ask the observer/reporter to share with the group members the sociogram, showing the flow of conversation. Who talked the most to whom? Why? Who talked the least? Why?

The "Sensory Discovery Lists" (pp. 63–66) provide an opportunity to lead participants in enjoyable, creative learning experiences. As teachers become more aware, they are better equipped to lead their students to become more aware. Suggested below are some experiences you can use. Use your imagination to construct other similar experiences that focus on sensory experiences.

- Ask the participants to close their eyes and listen. Ask, What do you hear that you might not have heard if you had not done this?
- Ask the participants to take a five-minute walk outside and mentally record the objects of nature they see. Call for their reports. Ask, How often do we fail to "see" these objects?
- Ask three volunteers to allow themselves to be blindfolded. Ask them to smell of several objects and identify the objects. Suggested objects may include coffee, cheese, fruit, etc....
- Add to this list from your own creativity.

Continue by asking the participants to complete the "Awareness Development Activities" (pp. 67–68) and to share their answers with the other participants.

Call attention to the "Teaching Strategies in the School" (pp. 69–71). Ask the participants to note the strategies they use most and the ones they use least. Ask, What factors determine appropriate strategies in a given situation?

Call attention to the "Taba Model" (p. 73). Preview the types of questions in the model. Then ask participants to construct a question that illustrates each overt activity in the model. Call for each participant to share while other participants evaluate.

Study carefully the objectives for this workshop and make assignments to participants accordingly. Most of these assignments will be completed outside the workshop session and can be reported in future sessions.

Creating an Atmosphere
for Creative Thinking

Objective A

By the end of the first week of school, teachers will modify physical atmosphere of the classroom to provide the following space arrangements and activity areas. (Gaitskell, 1970)

1. Individual and group work facilities by arranging furniture in flexible positions and by designating a quiet area.
2. Large open space for freedom of movement or activity area.
 a. Activity areas should include: (at least 6 out of the 9 items)
 (1) *Large open space* for resting, story telling, group discussions
 (2) *Sink area* at height of children with storage for powder paints, fingerpaints, clay bins, clay boards, rags, sponges, brushes, and paint containers
 (3) *Low shelves* for art supplies, toys and games; easily accessible for pupil use and exploration
 (4) *Painting area* which includes easels, smocks, and a dry area for completed compositions
 (5) *Play corner* for role playing (ex: playhouse furniture)
 (6) *Library area* with shelf storage for books and a reading table
 (7) *Work tables for teacher-specified materials* for particular tasks such as record player, finger painting, story writing, science projects, etc.
 (8) *Movable screens* to separate different areas
 (9) *Display areas*—bulletin boards, suspension objects such as coat-hangers, (mobiles), 3-D display boxes, and pegboards
 b. Art materials in each classroom should include:

(1) wax crayons in 8-12 colors including black and white
(2) chalk in 8-12 colors including black and white
(3) paints in all primary colors and black and white along with containers for each color in each easel
(4) paste and glue and individual containers
(5) scissors for each child and a container
(6) brushes—flat hog bristle 1/4" - 1", and sable pointed in sizes 6-7
(7) paper—roll of brown craft paper, manila 18 x 24, colored construction paper 12 x 18 in 8-12 colors, plus black and white
(8) clay in air tight containers with clayboards for each child
(9) various odds and ends of junk material, old containers, strings, newspapers, wire, yarn, straws, material, buttons, and tools for cutting wire and boxes; hammer, etc.

Checklist for Objective A

_____ Individual and group work facilities

_____ Designated quiet area

_____ Large open space

_____ Low shelves for art supplies, within reach of pupils

_____ Painting area

_____ Play corner

_____ Library area

_____ Work tables with teacher's tasks

_____ Movable screens separating areas

_____ Display areas

_____ Majority of the art materials

Developing a Low-Risk Environment

Objective B

Each teacher will develop a low risk environment by practicing at least 5 out of 10 procedures to help a child experience his own creativity without fear of criticism or being wrong. (Leeper, 1974)

1. The teacher will:
 a. discard regimented routines, such as following directions for drawing in a particular way or using patterns or models to be imitated
 b. show children their ideas have value by using positive encouraging statements about the children's ideas
 c. be attentive to children's questions and develop a warm friendly atmosphere by discussing questions to show they are welcomed
 d. give credit for self-initiated learning using praising statements
 e. emphasize the good parts of a child's work to instill a feeling of success
 f. provide chances for learning and discovery without threats of immediate evaluation
 g. select materials suitable to the child's work
 h. give ample time for completion of the child's work
 i. ask questions to help the child form a mental image of what he desires to do
 j. be impartial and fair to help encourage self-expression

Checklist for Objective B

The teacher:

_____ has discarded regimented routines in art such as having the children draw in a particular pattern or by having models to be imitated

_____ shows children their ideas have value by encouraging original ideas

_____ is attentive to children's questions and presents a warm and friendly atmosphere

_____ gives credit for self-initiated learning in every subject

_____ emphasizes the good parts of a child's work and instills a feeling of success in the child

_____ provides chances for learning and discovery without threats of immediate evaluation

_____ selects materials suitable to the child's physical and mental capabilities to avoid frustrations

_____ gives ample time for completion of the child's work

_____ asks questions to help the child form a mental image of what he desires to do

_____ is impartial and fair (encourages self-expression)

Sociogram

Objective C

The teacher will implement and analyze a sociogram within the first six weeks of school and arrange pupil work groups or art groups to promote non–status achievers' self-esteem. Write a brief (1 page) report on the results of your classroom arrangement.

1. The teacher will ask each child to write his name on a 3 x 5 card. Then ask: "With whom would you like to work on a

Chooser \ Chosen	David	Jane	John	Karen	Martha	Pat	Robert	Rose	Stephen	Stewart	Susan	Walter
David			1				2		3			
Jane			3	1	2							
John	2					1			3			
Karen		1			2					3		
Martha		1							2	3		
Pat		3	1				2					
Robert	2		1					3				
Rose		1		3						2		
Stephen	2		1			3						
Stewart	2	3	1									
Susan		1	3	2								
Walter			3					2	1			
1st choice	0	4	5	1				0	0	1	0	0
2nd choice	4	0	0	1	2		1	0	2	1	1	0
3 choice	0	2	3	1				0	1	2	2	0
		4						0		4		

Tabulation form showing the choices of seven boys and five girls adapted from Helen Hall Jenkins, Sociometry in Group Relations.

job? Who is your second choice? Third choice?" After each card has been completed, transfer information to the tabulation form, then to the sociogram. Analysis should show those students who have achieved peer status and those who have not. With this information, the teacher can balance non–status achievers with high–status achievers in various fields such as language arts, math, music, art, etc. For non–status achievers, the groupings should increase their acceptance and thereby increase self-esteem.

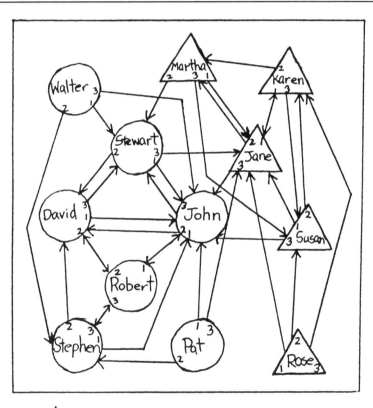

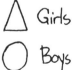

Sociogram Survey for Objective C

Directions: Circle the number which best describes your attitude toward these statements on constructing a sociogram.

1. Constructing a sociogram is helpful in discovering class social status leaders.

4	3	2	1
Strongly agree	Agree	Tend to disagree	Disagree

2. Sociogram information helped me be aware of peer groups.

4	3	2	1
Strongly agree	Agree	Tend to disagree	Disagree

3. Construction of a sociogram helped me group children to promote social harmony.

4	3	2	1
Strongly agree	Agree	Tend to disagree	Disagree

4. Construction of a sociogram helped group children to benefit from each other's creative talents.

4	3	2	1
Strongly agree	Agree	Tend to disagree	Disagree

5. Sociogram information allowed me to place non–status achievers with status achievers and thereby increase self-esteem and acceptance by the non–status achievers.

4	3	2	1
Strongly agree	Agree	Tend to disagree	Disagree

6. Sociograms are very useful and I will use them for future class groupings.

4	3	2	1
Strongly agree	Agree	Tend to disagree	Disagree

Some Guidelines for Designing Awareness Activities

1. Have the student become involved in a physical act of moving, if possible, while taking in information. This same physical act will help later in the recall of the information taken in.
2. Have the student relate to the new knowledge or perception to something he already knows.
3. Do not tell him exactly what or how to perceive. Let him discover as much as he can by himself and then ask questions that will help him structure and continue his inquiry.
4. Use the actual object, if possible, while increasing knowledge and awareness. Do not try to do everything at the abstract verbal level. (Linderman and Herberholtz, 1974)

Sensory Discovery Lists

Sights That We Discover

How many sights have you observed?

	YES	NO
dew on the grass	___	___
rays of sunshine through the clouds	___	___
frosty windows in winter	___	___
a wet spider web	___	___
a full moon	___	___
a baby sleeping	___	___
polliwog eggs with little black specks in them	___	___
an anthill	___	___
the cream-colored pattern on top of a crab shell	___	___
watch armed robbers pass 3 feet in front of you	___	___
changing of the sea during an entire day	___	___
dark brown eyes	___	___
the endlessness of looking across the ocean	___	___
a dog rubbing his nose with his paw	___	___
a snake in the grass	___	___
freshly picked peaches	___	___
gum stuck to the bottom of one's shoe	___	___
catching someone's eye in a shared experience	___	___
the surface of your tongue	___	___
the inside of a dog's ear	___	___
pools of sunlight under the trees	___	___
a thick fog starting to roll in	___	___
snow blowing past a lamp	___	___

Add some unusual experiences here:

Sounds That We Discover

How many sounds have you heard?

	YES	NO
rain on a roof	___	___
trains in the night	___	___
roosters crowing	___	___
car horns tooting	___	___
dripping faucet	___	___
dental drill (emotional reaction)	___	___
jackhammer	___	___
water rushing over rocks	___	___
birds singing in the morning	___	___
wood crackling in the fireplace	___	___
wind in the trees	___	___
a squeaking hinge	___	___
thunder in the distant sky	___	___
hiss of a snake	___	___
crunch of snow beneath our feet	___	___
walking in wet tennis shoes	___	___
lonely sound of a gull in the wind	___	___
sound of the ocean	___	___
throaty buzz of a chain saw	___	___

chatter of an old dog's teeth _____ _____

smack of a kiss _____ _____

whine of wire when stretched tightly _____ _____

sound of a sickle in the grass _____ _____

cows chewing hay _____ _____

lambs nursing on bottles _____ _____

thump on a watermelon _____ _____

water breaking against the bow of a ship _____ _____

click of a light switch _____ _____

scratching our skin _____ _____

hanging up the telephone _____ _____

tea kettle boiling _____ _____

a telephone in the night _____ _____

squealing brakes _____ _____

fingernail on the blackboard _____ _____

crying of an adult _____ _____

radio static _____ _____

a cat howling _____ _____

supersonic boom of a jet _____ _____

cracking of knuckles _____ _____

growling of the stomach _____ _____

gum cracking _____ _____

Add more sounds here:

Smells We Discover

How many smells have you noticed?

	YES	NO
after-shave lotion	____	____
coffee perking	____	____
new shoes	____	____
freshly cut grass	____	____
hot tar	____	____
cigar smoke	____	____
wet dog	____	____
sour milk (repugnant)	____	____
hayfield	____	____
baby right after bath	____	____
onion factory	____	____
wet bathing suits	____	____
the air after a summer rain	____	____
musty old books	____	____
smell of the ocean	____	____
bread from the oven	____	____
dead whale on a smelly beach	____	____
closed-up rooms	____	____

Add more smells to your list here:

Awareness Development Activities

Developing Awareness Through Experiences

Experience Check Chart

	YES	NO
planted flower seeds and watched them grow	____	____
bought a bouquet of flowers	____	____
picked or cut flowers	____	____
given someone flowers on a special occasion	____	____
smelled flowers in relation to funerals, weddings, state fairs, etc.	____	____
held or carried flowers on May Day, for a wedding, or for your mother as she cut them	____	____
worn a flower for a special occasion	____	____
arranged flowers for a table	____	____
visited a florist shop or flower garden	____	____
destroyed a flower to see how it is put together	____	____

Developing Awareness Through Empathy or Identification

Empathy Check Chart

	YES	NO
to have the sun warm you	____	____
to open in the morning and close at night	____	____
to fall off the bush	____	____
to feel the dew collect on you at night	____	____
to have a bee take nectar from you	____	____
to wave in the wind and bump into other flowers	____	____
to get cold at night	____	____
to turn and face the sun	____	____

to be pulled, picked, or cut off ____ ____
to have someone put his nose in your face and sniff ____ ____
to have bugs crawl over you, maybe even eat you ____ ____
to feel the rain beat on you during a thunderstorm ____ ____
to be a flower of many colors ____ ____
to open from a tiny bud to a full blossom ____ ____
to change from the flower to the seed ____ ____

Developing Awareness Through Experiencing Details

Detail Check Chart

	YES	NO
the weight of the flower	____	____
how soft or hard the petals are	____	____
how long the petals are	____	____
how easily the petals break or fall off	____	____
how easily the petals bend	____	____
the amount of moisture in the flower	____	____
how fragile and hollow the stem is	____	____
where the stamen is	____	____
where the nectar is	____	____
the hair follicles growing in the petals	____	____
whether or not the petals have veins	____	____
whether the stem breaks easily	____	____
the shape of the petals	____	____
what it feels like to rub the petals on your cheek	____	____
how the flower might taste	____	____
how it smells	____	____
how the color in the petals changes or blends	____	____

Teaching Strategies in the School

Teaching Strategy Defined:

"Patterns of teacher behavior that are recurrent, applicable to various subject matters, characteristic of more than one teacher, and relevant to learning."

Robert L. Ebel (ed.)
Encyclopedia of Educational Research
N.Y.: Macmillan Co., 1969, p. 1446.

1. Lecture
 • Used to introduce new topic of study
 • Used with appropriate multisensory aids to increase student attention and interest
 • Used with opportunities for student-teacher interactions to check on understanding and allow for student ideas to be incorporated
2. Discussion
 • Built around student ideas, questions
 • Planned to raise thinking level of students
3. Drill and Practice
 • Meaningful repetition of previously introduced concepts
 • To increase proficiency (practice)
 • To facilitate retention (drill)
4. Independent Study
 • To aid students in self-improvement
 • May be self-initiated or teacher-guided through a process of identifying the problem, locating resources, planning the procedures to be used, and helping with evaluation of progress.

- Emphasizes the learner's responsibility and accountability and therefore promotes feelings of independence and self-discipline.
5. Group Investigation
 - Allows students to use inquiry skills
 - Provides opportunities for more intensive investigation of a problem
6. Laboratory Approach (Experiments, field trips, demonstrations)
 - Emphasizes direct experience with materials pertinent to the area of study.
 - Teacher observation and participation skills
 - Multi-sensory approach provides for individual learning styles
 - Experiences provided are apt to be highly relevant to understandings outside of the school setting.
7. Discovery
 - Emphasizes individual study, manipulation of objects *before* generalizations (rules) are verbalized
 - Includes teaching skills of inquiry and problem solving as tools for the student
 - Allows student to be guided toward his own "discovery" of the rule so depth of understanding, retention and transfer is increased.
8. The Learning Center
 - Wide assortment of resources for learning
 - Emphasis on making observable gains in learning
 - Emphasis on pupil's self-management of learning
 - Provides for repeated encounters with concrete experiences
 - Can be used to develop understandings, skills, attitudes
 - Allows students to proceed at their own pace.
9. Simulation (Role-playing, Sociodrama, Simulation Games)
 - Provides adult-type encounters without fear of serious reprisal from wrong actions or judgments.
 - Allows students to crawl into the skin of another person for better understanding of motivations that prompt behavior.

- Gives opportunities to explore alternative solutions to problems of concern to the group.
- Reduces level of abstraction
- Promotes and rewards critical thinking.

10. Behavior Modification
 - Rewards behavior you want to encourage and changes inappropriate behavior to a more acceptable action.
 - Used properly, it improves student/teacher interaction
 - Used properly, students find that success in learning can be its own reward
 - Programmed learning materials break the concepts to be learned into many small, sequential tasks with a high likelihood of successful completion.

11. Performance-Based Learning Activity Packages (also called competency-based instruction)
 Provides precise objectives in behavioral terms.
 - Provides pupil with criteria for successful completion of skills
 - Designed to provide individualized learning experiences for students
 - Allows student to work at his own rate and to be evaluated without comparison with others
 - A diagnostic approach to teaching

12. Do–Look–Learn
 - Emphasizes *doing*. Provides an activity for a group of two to six students
 - Group members evaluate the processes involved in doing the activity and make improvements as needed for dealing with the task.
 - Provides follow-up to emphasize what was learned and how to apply it to other situations
 - Derived from research on ways people function and learn in groups
 - Focuses both on a learning objective and on the group processes involved in accomplishing that objective.

Questioning Skills

Taba's Model

Concept Formation		
Overt Activity	**Covert Mental Operation**	**Eliciting Question**
Enumeration and listing	Differentiation	• What did you see? hear? note?
Grouping	Identifying common problems; abstracting	• What belongs together? • On what criterion?
Labeling, categorizing, subsuming	Determining the hierarchial order of items; super- and subordination	• How would you call these groups? • What belongs under what?
Interpretation of Data		
Overt Activity	**Covert Mental Operation**	**Eliciting Question**
Identifying Points	Differentiation	• What did you note? see? find?
Explaining items of identified information	Relating points to each other; determining cause-and-effect relationships	• Why did so-and-so happen?
Making inferences	Going beyond what is given; finding implications, extrapolating	• What does this mean? • What picture does it create in your mind? • What would you conclude?

Application of Principles		
Overt Activity	Covert Mental Operation	Eliciting Question
Predicting consequences, explaining unfamiliar phenomena, hypothesizing	Analyzing the nature of the problem or situation; retrieving relevant knowledge.	• What would happen if...?
Explaining, supporting the predictions and hypotheses	Determining the causal links leading to prediction or hypothesis	• Why do you think this would happen?
Verifying the prediction	Using logical principles of factual knowledge to determine necessary and sufficient conditions	• What would it take for so-and-so to be true or probably true?

Workshop 2
Notes and Reactions

Workshop 3
Creative Visual Expression

At the completion of Workshop 3, each person will explore various techniques in motivation, manipulation, and experimentation of different media in the production of creative visual expression.

Objectives

A. By introduction of the following ideas for visual enrichment and motivation, the teacher will be able to guide the children in manipulation of various art media in the production of new ideas. The teacher will use at least one motivational idea once a week. See motivational resources.
B. Through experimentation with media, the teacher will be able to demonstrate her knowledge of at least three different ways to use the following media.
C. The teacher will use media in objective two to plan two activities per week to guide children in the manipulation of different media. See sample lessons.
D. By using many different tools and materials, the teacher will be able to guide the children in their exploration and experimentation of media. The teacher will plan one activity per week in this area of experimentation with materials. For suggested explorations see sample lessons.
E. The teacher will apply media techniques in the development of perceptual awareness.
F. The teacher will apply media techniques in the development of suitable classroom environment.
G. Using the following discarded "junk," the teacher will be able to guide the children in the construction of a visual art form. The teacher will prepare one construction lesson each three weeks, for a total of five lessons. For sample lesson, see text.

Evaluation for each objective will occur on a weekly basis as each teacher completes the activities as outlined on the Scope and Sequence Chart. Discussion of the activities in the workshops will also be part of the evaluation.

Suggested Workshop Procedures for Facilitators

Call for reports on assignments from previous workshops. Ask participants to share unusual experiences they have had as they completed their assignments.

This workshop focuses on creative visual expression.

Begin by giving a brief overview of the objectives of this workshop. Make assignments as called for.

Using the information in the section on "Motivational Resources," call attention to the numerous ordinary objects that can be used in creative ways and to teach creative thinking. In advance, make a display of these objects. (You may want to involve the participants in gathering these objects. Remember, the more the better. Divide the participants into pairs. Ask them to choose one or two of the objects displayed and develop creative uses for these objects. Call for reports to the entire group.

There are several sample lessons outlined in this workshop. Assign these lessons to individuals to develop in a way that illustrates how they can be used. Allow these individuals time to report to the group and to discuss modifications that may be beneficial.

Call attention to the list of material in the section on "Art Supplies." Ask each participant to report individually on specific ways one or more of these art supplies can be used.

Make assignments for each participant to make a finger paint recipe and to bring it to the workshop. Display newsprint and ask each participant to complete a finger painting, using any or all of the recipes that have been made.

Motivational Resources

mounted birds, fish, animals

Santos figures from New Mexico and Philippines

acetate, celluloid, Plexiglas sheets in various colors

colored tissue paper

day glo colors and papers

spotlights

an aquarium of colorful tropical fish

full length and face mirrors

ant farm or bee colony

Japanese paper fish kites

bells from Far East

glass fishing floats

colorful umbrellas

Antique Americana

duck decoys

contemporary and travel posters

indoor plants

Eskimo sculpture in soapstone or whalebone

old lamps

bird cages and birds

fish netting

theatrical costumes and face make-up

puppets from different countries

Indian corn, hedge apples, gourds, squash

bicycles, motorcycles, helmets

Indian Kachina or Japanese Kokeshi dolls

sports equipment

magnifying glass

multicolored glass containers

masks: African, Mexican, Japanese No or Bagaku, Clown, Mardi Gras, Indian, Mexican

assorted bottles

stained glass

cloth remnants

Indian pottery

yarn remnants

butterfly, sea shell collections

wallpaper sample books

films, filmstrips, slides

model cars, engines

music

musical instruments

Navajo Indian rugs

old fashioned hats

lanterns, clocks

texture table

The following can also be sources of motivation toward creativity:

1. Reproductions of paintings, sculpture, prints, crafts to supplement, illuminate, intensify objectives of project.
2. Photographs in color and black and white to extend the visual store of experience.
3. Color slides of paintings, drawings, sculpture, prints, architecture; designs in nature, manmade objects, creative work by other children; work illustrating technical stages of project; shots of people in action sports, costume; animals, birds, fish, insects when the real thing is not possible.
4. Filmstrips, tapes on art techniques, art history; and on correlated subject matter such as biology, anthropology, botany, geology, geography, travel, space exploration, technology.
5. Films, TV films, and tapes that apply to a particular theme to broaden the experience and net a more diversified outcome.
6. Books, stories, plays, poems, biographies, periodicals, pamphlets to give richer interpretation of subject matter.
7. Recordings; music dramatizations, poetry; sounds of various geographic regions; country and city sounds; nature's forces; machines, ships, trains, rockets; circuses and fairs to heighten auditory awareness.
8. Guest speakers, performers, models; astronauts, traffic officers, clowns, dancers, actors, scuba divers, pilots, athletes, singing groups, and musicians.
9. Resources and sketching trips to science, historical, art museums and galleries, artists; studios, farms, factories, wharves, airports, observatories, bus and railroad terminals,bridge sites, national parks, zoos, shopping centers, historical monuments, and boat marinas.
10. Models for art class observation for drawing may include: live or mounted animals, birds, fish, flowers, plant life, dried fall weeds, beehives, bird nests, insect or butterfly collections, fish in aquariums, terrariums, ant colonies,

pets, skulls, rocks, pebbles, fossils, seaweed, seashells, also assorted still life materials: fruit, vegetables, lanterns, kettles, vases, clocks, teapots, bottles, fishnet, beach towels, burlap, bold patterned cloth remnants, and old lamps.

11. Artifacts from other cultures and countries, such as masks, carvings, containers, textiles, ceramics, toys, tools, icons, fetishes, dolls, and puppets.

12. Examples of other children's artwork in varied media to stimulate class production of new material.

13. Demonstrations of art techniques by teachers and students.

14. Constructive critique by students of art work in process, with the positive guidance of the teacher.

15. Introduction of a new material, tool, or new use for common materials or familiar tools (kitchen implements for shaping clay, etc.).

16. Planned exhibits, bulletin board displays that relate to the art project.

17. Introduction of an art design element or principle or a special emphasis on some compositional element, such asvalue, variety, texture, color, and relationship.

18. Assorted objects and equipment to help expand the students' visual horizons: microscopes, prisms, kaleidoscopes, color faceted eyeglasses, touch-me-kinetics, color machines, liquid light lamps, telescopes, microscopic projections, and black lights.

Source: *Emphasis Art,* Frank Wachowiak.

Sample Lessons

Sample Lesson: Collages

Objective: The student will be able to show an awareness that objects or forms of identical nature are alike and objects that are not identical are different, by correctly labeling objects alike or different.

Materials: Collection of items that are alike, different; include also objects that are alike in shape, but different in color.

Procedure:
1. The teacher will explain, through illustrations, objects that are alike, and then, objects that are different.
2. The teacher will show how some objects can be alike in some ways, but different in others.
3. Children will make a collage design using pictures from magazines to show their understanding of the concepts of alike and different. Paper could be divided in half, with one side for pictures that are alike, the other for pictures that are different.

Evaluation is based on correct placement of pictures that are alike and different in their collages.

Sample Lesson: Needlework

Objective: The student can utilize simple processes in stitchery and appliqué.

Procedure:
1. Discuss fabrics, what kind of things are made from them, and how they are decorated.
2. Direct students toward a discussion of terms such as stitchery, appliqué, knitting, embroidery, needlepoint, and weaving. Show examples.
3. Discuss experiences that the children and their family may have had with these processes.

Suggested Activities:

For the beginner—let him draw with thread and experiment with the types of thread and surfaces to be used.

At this experimental stage, activities might include:
1. Making yarn pictures by gluing yarn and fabric (appliquéing) to paper or board.
2. Weaving or stitching thread or yarn through a meshwork such as rigid hardware cloth, onion sacking, plastic screen, or other open weave fabric.
3. Making a "God's eye" by twisting yarn around crossed twigs or sticks.

When children have learned to thread a large-eyed needle, use the following activities:

1. Sewing on paper by outlining drawings or on thin tag-board or railroad board (by first making perforations) to initiate child to the possibilities of stitchery.
2. On a background of burlap or another loosely woven fabric make a picture or design with crayon. With contrasting yarn, using a large tapestry needle, stitch and appliqué the design in a variety of stitches.
3. Things to make or decorate: place mats, hot pads, marble bags, circular mats, purses, baskets, wall hangings, aprons, towels, pillow covers, hats, caps, scarves, rugs, and slippers.

Materials: papers, fabrics, yarn, oak tag, railroad board, crayons, scissors, twine, hoops, needles

Evaluation: When the student demonstrates understanding of stitchery and appliqué processes by his finished product, the objective is achieved. (*Art is Elementary*)*

Sample Lesson: Potato Prints

Objective: The child will be able to create a pattern by using a design in a regular sequence.
1. Discuss design, and how one produces a pattern through repeated design in a regular sequence.
2. Show examples of patterns—fabrics, wallpaper, gift wrap.
3. Show how to cut a potato to make a design and how to use it through printing, in a regular sequence to create a pattern.
4. Children will print a pattern on paper, to be used for wrapping Christmas presents.

Materials: potatoes, printing ink, paper, cutting tool

Evaluation: When the child demonstrates his understanding of patterns by his final product, the objective is achieved.

Sample Lesson: Drawing and Painting

Objective: The child will be able to use new techniques, processes,
in the production of visual art expression.

Materials: tempera paints, brushes, large paper, cardboard, fabric, string, sponges, small sticks, newspapers, chalk, crayons.

Procedures:
1. Discuss properties of colors, mixing colors in tempera paint.
2. Discuss and experiment with painting with sponges, sticks, etc. using volunteers in the classroom to produce examples.
3. Discuss and show examples of how to use other media such as chalk to change the effects of tempera. (What happens if we use chalk or crayon under the tempera? Does it show through? etc.)
4. Let children, equipped with the necessary tools and materials, experiment.

Evaluation: The finished product, executed with the use of new techniques, will show completion of the objective. (*Art is Elementary*)*

Sample Lesson: Creating Textures in Clay

Objective: The child creates textures in pliable materials by in-
denting.

Procedure:

1. Have displays set up on a table or on panels to hang on
 the wall. The display should include a variety of objects
 that have interesting shapes with which to make pat-
 terns or designs in clay as well as to create illusions of
 texture from imprinting. This display might include:
 pointed dowel sticks, tongue depressors, cookie cut-
 ters, combs, hair pins, burlap, coarse wall paper, screen
 wire, buttons, strainers, straining spoons, bottle
 openers, bottle caps, fruits, and vegetables (such as cab-
 bages and oranges) cut in half.
2. Have clay ready to use.
3. Motivate interest through questioning, such as: What is
 this stuff call that I'm working with? (Mold, shape, and
 manipulate clay in nonpurposeful way.) Have you ever
 worked with clay? What kind of things have you made
 with clay? Can I shape it or make designs in it? Can I
 use my finders as tools? What could I use as tools be-
 sides my fingers? (Hold up pointed dowel sticks.) What
 could I do with this tool to make designs or decorate
 the clay?
4. Have everyone flatten their clay on table and begin im-
 printing with the dowel sticks, making patterns.
5. Show objects in display and discuss the kind of patterns
 they might create in the clay.
6. Encourage children to select different tools and experi-
 ment with them and the clay.
7. For fast workers, have them roll their clay up and flatten
 it again, to try some new patterns and designs.
8. To elaborate on this lesson, one might have a subsequent
 lesson where the children make a bowl and imprint
 their "experimental" designs on it.

Evaluation: The objective is achieved when the child im-
prints his clay.

Source: Art is Elementary, Cornia, Stubbs, Winters.

Sample Lesson: Found Materials

Objective: The child creates construction from "found" materials.

Materials: Students can bring objects in, teacher can supply some of those suggested below, glue, scissors.

Procedure:

1. Discuss how artists put together "found" items in sculptural form in new combinations. Ask: How many things can you think of that have been glued, pasted, or nailed together? What are all the things you can think of that you would like to play with by gluing or fastening them together?
2. Brainstorm concerning things students or friends may have made with found objects.
3. Discuss the need to select materials which seem to "go together" because of some unifying characteristics.
4. Encourage students to sketch their ideas on paper and to make abstract designs with the materials they choose.
5. Emphasize patience: in coming up with ideas, and also in waiting for glue to dry before going on constructing.
6. Construct. Some ideas for construction:

egg cartons	wood
Leggs' eggs	construction paper scraps
fabric remnants	spools
yarn scraps	toothpicks
carpet, linoleum scraps	straws
leather scraps	meat trays
styrofoam packing	

Evaluation: When the student has created a construction, the objective has been achieved.

Sample Lesson: The Shadow

Objective: The student will demonstrate an awareness that people and objects cast shadows.

Materials:
1. Strong light in darkened room
2. White sheet with a variety of objects to show behind it
3. Pictures that show objects or people with their shadows
4. Premade silhouettes of several class members

Procedure:
1. Concept introduced with story of Peter Pan and his lost shadow.
2. Show class a lost shadow (silhouette of class member). Ask: "I wonder who it belongs to?" Have several try to find shadow's owner. Afterwards ask: "Does your shadow look like this?" "Have you ever lost your shadow?" "Can you roll up your shadow and put it under your pillow?"
3. Bring out concept that a "shadow is yours because you block out the light and it usually looks like you."
4. Involve children in making shadows with the sheet and projector set-up. Guess what students belong to shadows. Have students hold objects behind sheet and let others guess what it is.
5. Read "My Shadow," Robert Louis Stevenson (*Poems and Rhymes,* Childcraft, Vol. 1. Chicago: Field Enterprises Educational Corp., 1975, p. 82.)

Evaluation: Have students draw something and show its shadow. Students' awareness of concept can be seen in drawing and class discussions. (Cornia, Stubbs, and Winters, 1976)

The following are two art lesson plans which include objectives for developing particular creative thinking skills from the theoretical model. These are given as examples for teachers to follow in developing their own lesson plans that encourage the development of creative thinking skills.

Sample Lesson

Objectives:
1. The child will be able to see and produce many possible combinations or new relationships in colors (from creative thinking skills hierarchy—Level I.)
2. The student will demonstrate an awareness that black or white can be used to change the value of any color, and the value of the color is directly related to its relative closeness to black or white.

Materials: tempera colors, paper, brushes, color chips

Procedure:
1. Discussion of the term "value" (variations in darkness and lightness). Demonstrate making variations of gray with black and white by mixing and painting strips of color on paper.
2. Ask: "If there are that many variations of gray possible, are there as many variations of every color possible, too?" (None will go as dark as black or as light as white and still retain their identity, but many variations of each color are possible.) Discuss value of colors to each other and to black and white.
3. Have someone line up all of the people wearing a given color in order of their darkness and lightness. Ask: "If we had all the colors you see before you as paint in jars and we wanted to make all the blues (or whatever color) as dark as the darkest one, what would we mix with each?" "Would we add the same amount for each?"
4. Have students experiment by mixing colors with black and white. Have them see how many variations they can make.
5. Have students arrange color chips in order from dark to light.

Evaluation: Arranging and mixing colors from dark to light will show completion of objectives. (Cornia, Stubbs, and Winters, 1976)

Besides illustrating how creative thinking skills can be encouraged in lesson planning, the following shows how several objectives from different goals can be implemented into one lesson plan.

Sample Lesson: Colors

Objectives:
1. The child will be able to produce new combinations through manipulation of primary colors.
2. The student will demonstrate the ability to predict what specific colors will result when he mixes two colors.
3. The child will be able to use new techniques and processes in the production of colors.

Materials: watercolors (red, blue, yellow), art paper, brushes, sponges, sticks, prisms, crayons, tissue paper (primary colors), glue, scissors, color wheel.

Procedure:
1. Children will experiment with prisms and light. Discussion will follow concerning the colors seen and how they are formed.

Art Media

Medium	Suggested Uses
tempera	• tempera-India ink batik • soap and tempera fingerpaint • easel painting
crayon	• crayon resist • crayon encaustic • crayon engraving • crayon drawing • crayon batik
oil pastel	• oil pastel sketch • oil pastel drawing • oil pastel resist
collage	• collograph • "junk" collage • tissue paper collage • magazine collage • tissue paper/ink collage
construction paper	• collage • mosaics • cut-out shapes
prints	• monoprint • linoleum • vegetable • wood block • silk screen
clay: marblex earth clay modeling clay	• ceramics • sculpture • shape experimentation • making practical objects

plaster	castingplaster reliefmolding
fabric	collageappliquéembroiderystitchery
metal	embossingengravingmobilesstabiles
India Ink	drawingtempera resistaluminum foil reliefmonoprint
watercolors	painting
weaving	standing loomhand loom
charcoal, chalk, pastel	sketchdrawingshading
sand — wet or dry	sand reliefcastlesshapesmoldingpendulum cone with sand flowing out of ittrace designs on a surface
dirt	buildmodelgrow plants in itfind living things in it
water	used in paintinguse with sand, dirt, claytub for water playsoap, hoses, water dropperscolor water with food dye

Art Supplies

Art supplies can be traditional media, or may involve explorations of new and different materials. A basic supply list of traditional materials would include the following:

tempera	plaster
crayons	fabric scraps
oil pastels	aluminum foil
thin sheet metal	tissue paper
construction paper	India ink
tag board	watercolors
linoleum blocks	charcoal
brayers	chalk
printing ink	pastels
silk screen frame	scissors
silk screen film	glue
marblex clay	pencils
earth clay	paper cutter
modeling clay	brushes (all sizes)
drawing paper, 18 x 24	

The following are some suggested explorations:

A. Have you ever painted with:

watercolors	glue
poster paint	condensed milk
muddy water	India ink
corn syrup	tea
food dyes	coffee
liquid shoe polish	egg tempera
melted crayons	rubber base enamels
rubber cement	berry juices
bleach	buttermilk
liquid wax	

B. Some different tools and materials to paint with or on:

cellophane	corrugated cardboard
paper towels	carbon
pressed cardboard	corks
butcher paper	soft sugar pine
sprayers	waxed paper
weathered boards	bottle brush
dish scrapers	wood
pencil	stone
crayon	house brush
cloth	fingers
paste brush	spools
sticks	solder brush
erasers	hard bristle brushes
straws	saran wrap
feathers	straw or hay
soldering wire	acetate
sponges	masonite
toothpick	rags
sidewalks	bamboo
nails	driveways
plastic bottles	newsprint
chalkboard	paper plates
bone	hard soil
glass	paper bags
sand	soap
chalk	blocks of wood
tissue paper	ink pens
manila rope	crepe paper
aluminum foil	

Source: *Linderman, Developing Artistic and Perceptual Awareness.*

Finger Paint Recipes

Finger paint can be purchased commercially or can be made by any of the following recipes. All finger paints should be stored in tightly covered jars and in a cool place. Source: *A Child Goes Forth,* pp. 40–41.

Method #1

> One 12 oz. box of cold water starch
> An equal amount of soap *flakes*
> Powder paint for coloring
> 2 cups cold water

Mix together the starch and soap flakes. Slowly add the water while stirring. Mix and beat until it reaches the consistency of whipped potatoes. Add tempera—dark colors show up more effectively than light colors.

Method #2

Moisten 1 cup laundry starch with 1 cup cold water, add 2 cups hot water and cook until thick. Remove from heat and add 1 cup soap flakes and a few drops of glycerin.

Method #3

Mix together in double boiler 1 cup flour, 1 teaspoon salt and three cups cold water. Cook until thick, beating with an egg beater or electric mixer.

Cornstarch Finger Paint

Dissolve 1/2 cup of cornstarch in 4 cups of boiling water and stir. Let mixture come to a boil again. Cooling causes paint to thicken slightly.

Wallpaper Paste Finger Paint

Put amount of water you desire into a pan. Sprinkle four on top of water, a small amount at a time. Stir in a circular motion until all lumps are gone. Add more flour until desired consistency. (Desired consistency should be similar to Sta-Flo laundry starch.)

Starch and Soapflake Finger Paint:

1/2 cup linen starch
1-1/2 cups boiling water
1/2 cup soap *flakes*
1 tablespoon glycerin (optional, but makes it
 smoother)
food coloring
Mix starch with enough cold water to make smooth paste. Add boiling water and cook until glossy. Stir in soap flakes while mixture is warm. When cool, add glycerin and coloring. (the addition of 1 1/2 cups salt will change the texture.)

Soap Flakes

Put soap flakes into mixing bowl and add water gradually while beating with egg beater or electric mixer. Consistency should be about the same as stiffly beaten egg whites. Add color.

Salt and Flour Finger Paint

Stir 1 cup flour and 1 1/2 cups salt into 3/4 cup water. Add coloring. The paint will have a grainy quality.

Starch Finger Paint

Combine and cook until thick:
 one 1 lb. box of gloss starch
 1 cup soap flakes
 1/2 cup talcum powder
 4 quarts warm water
For preservation and fragrance, add cologne, oil of cloves or wintergreen.

Liquid Starch Finger Paint

Pour liquid starch on wet surface. Add color, if desired.

Starch-Gelatin Finger Paint

Combine 1/2 cup laundry starch and 3/4 cup of cold water in saucepan. Soak 1 envelope unflavored gelatin in 1/4 cup cold water. Add 2 cups hot water to starch mixture and cook, stirring constantly over medium heat until mixture comes to a boil and is clear. Remove from heat and blend in softened gelatin. Add 1/2 cup soap flakes and stir until mixture thickens and soap is thoroughly dissolved. Makes about 3 cups.

Pudding Finger Paint

Instant or cooked pudding may be used for a different experience. When food stuffs are used in this manner, define for children "today we're finger painting with ___. Another day we will have it for a snack."

Workshop 3
Notes and Reactions

Workshop 4
School and Community

At the completion of Workshop IV each person will develop communications to foster understanding of the need for creative awareness in the school and community.

Objectives:

A. Each teacher will place an exhibit that is the product of children in a downtown merchants store the last week in each month.
B. Each teacher will relate to parents via newsletters what is happening in the classroom the last week in each month. This newsletter is to be written as a joint effort between students and teachers.
C. Following the workshop, the teacher will be able to list at least three ways by which communication from school to home can occur.

Suggested Workshop
Procedures for Facilitators

Call for reports on any assignments made in previous sessions.

Read aloud the three objectives for this session. Then divide the participants into three task groups. Make the following assignments.

Group 1. What kinds of displays might be exhibited in store windows in the community? What are the most appropriate stores for the displays?

Group 2. What should be contained in the monthly newsletter? What should it look like? How can the evaluation sheet (p. 106) be distributed and returned? Construct an example of a newsletter to share with the group.

Group 3. What are the various ways that communication between the school and the home can be facilitated? Be as thorough as possible.

Each task group should be allowed time to report on their findings.

Conclude the workshop by asking participants to complete again the "Pre and Post Assessment" (pp. 19–20) and compare the results with the pretest.

Evaluations:

A. Observation by a curriculum member.

B. Parents survey:

 Circle the number which best describes your feelings about the newsletter you receive each month about creative projects in school.

1. The newsletter informs me of the classroom creative activities.

4	3	2	1
Strongly agree	Agree	Tend to disagree	Disagree

2. The newsletter allows me to share creative ideas with my child.

4	3	2	1
Strongly agree	Agree	Tend to disagree	Disagree

3. I would enjoy reading the newsletter each month and wish it would continue.

4	3	2	1
Strongly agree	Agree	Tend to disagree	Disagree

C. Name three ways to communicate schoolroom activities to home and community.

Creative Traits—
A Guide for Parents

Check your child's traits:

_____ strong affection

_____ always baffled by something

_____ altruistic

_____ attempts difficult jobs

_____ attracted to mysteries

_____ bashful outwardly

_____ constructive in criticism

_____ courageous

_____ deep and conscientious convictions

_____ defies conventions of courtesy

_____ defies conventions of health

_____ desires to excel

_____ determination

_____ differentiated value-hierarchy

_____ discontented

_____ dominant (not in a power sense)

_____ a fault finder

_____ likes solitude

_____ doesn't fear being thought "different"

_____ feels whole parade is out-of-step

_____ industrious

_____ introversive

_____ keeps unusual hours

_____ lacks business ability

_____ makes mistakes

_____ not hostile or negativistic

_____ oddities of habit

_____ persistent

_____ receptive to ideas of others

_____ regresses occasionally

_____ reserved

_____ resolute

_____ self-starter

_____ sense of destiny

_____ shuns power

_____ sincere

_____ not interested in small details

_____ speculative

_____ spirited in disagreement

_____ tenacious

_____ thorough

_____ somewhat uncultured, primitive

_____ unsophisticated, naive

_____ unwilling to attempt anything on mere say so

_____ versatile

_____ willing to take risk

Pre and Post Assessment

To be completed by the participants at the beginning and at the end of the series of workshops.

Self-Evaluation

Is My Creative Program a Multicolored Thing?
Color Code:
1) No, color all squares black.
2) Some, color any two squares green.
3) Most of the time, color three squares red.
4) All of the time, color three squares blue.
5) All this and more, color squares multicolored.

- Do I realize that each individual does create? ☐ ☐ ☐

- Do I encourage children to be more alert perceptually in their reactions to their world of experience? ☐ ☐ ☐

- Do I motivate children to explore new ideas, to be original in their thoughts, to dream about new possibilites and to imagine and pretend? ☐ ☐ ☐

- Do I motivate students to investigate the nature of things, to seek facts and knowledge, to discover new relationships and transform them into their own products? ☐ ☐ ☐

- Do I lead children to discover and to be sensitive to aesthetic stimuli in both usual and unusual places? ☐ ☐ ☐

- Do I give lively animated surefire demonstrations in relation to techniques and procedures? (This should include smiling.) ☐ ☐ ☐

- Do I keep children's development levels in mind when planning lessons, so that they are neither bored nor frustrated? ☐ ☐ ☐

- Do I love to teach creatively (not just on Friday afternoon)? ☐ ☐ ☐

- Do I encourage children to apply divergent thinking to standard materials as well as junk materials? ☐ ☐ ☐

- Do I analyze sensory perceptions in detail and teach chlidren how to perceive many details of one object or experience and encourage them to synthesize details into unique configurations? ☐ ☐ ☐

- Do I successfully motivate the child for an expressive experience and assist him or her in creating an aesthetic expression? ☐ ☐ ☐

- Do I praise my fellow teachers who provide creative experiences for their children? ☐ ☐ ☐

- Do I schedule at least three periods each week for creativity? ☐ ☐ ☐

- Do I have examples in my room to illustrate our heritage and to provide motivation for future works? ☐ ☐ ☐

- Do I have an adequate way to dispense supplies in the classroom so that I am not discouraged from using certain materials such as clay, poster paints, or plaster? ☐ ☐ ☐

- Do I arrange my room to make production easy? ☐ ☐ ☐

- Do I value my teaching as a worthwhile experience for all children and project this attitude during my lessons? ☐ ☐ ☐

(Adapted from: *Developing Artistic and Perceptual Awareness*, pp. 158–160)

Workshop 4
Notes and Reactions

Bibliography

Adams, D., and Hamm, M. (1989). "Creativity basic skills and computing: A conceptual intersection with implications for eduation." *The Journal of Creative Behavior,* 23 (4), 258–252.

Ausebel, D. P. (1964). "Creativity, General Creative Abilities and the Creative Individual." *Psychology in the Schools,* 1, 344– 347.

Brown, Lewis, Harderood. *AV Instruction: Technology, Media, and Methods,* 4th ed. New York: McGraw-Hill, 1973.

Cornia, Stubbs, Winters. *Art is Elementary: Teaching Visual Thinking Through Art Concepts.* Provo, Utah: Brigham Young University Press, 1976.

Dacey, J. S. (1989). "Peak Periods of Creative Growth Across the Lifespan." *The Journal of Creative Behavior,* 23 (4), 224–237.

Dacey, J. S. and Ripple, R. E. (1967). "The Facilitation of Problem Solving and Verbal Creativity by Exposure to Programmed Instruction." *Psychology in the Schools,* 4 (3), 240–245.

Davis, G. A. (1989). "Testing for Creative Potential." *Contemporary Educational Psychology,* 14, (3), 257–274.

Dennis, W. (1966). "Creative Productivity between 20 and 80 Years." *Journal of Gerontology,* 21, 1–8.

Dormen L., and Edidin P. (1989). "Original Spin." *Psychology Today,* 47–51.

Eisner, Eliot W. *Educating Artistic Vision.* New York: Macmillan Co., 1972.

Feldman, Edmund. *Becoming Human through Art: Aesthetic Experience in the School.* Englewood Cliffs, N.J.: Prentice-Hall, Inc., 1970.

Gaitskell, Charles D., and Hurwitz, Al. *Children and Their Art.* New York: Harcourt, Brace & World, 1970, p. 128.

Glover, J. A. and Bruning, R. H. (1990). *Problem Solving and Creativity. Educational Psychology Principles and Applications* (pp. 180–217). Illinois: Scott, Foresman/Little, Brown Higher Education.

Hakuta, K. (1988). "A Conversation with Ken 'Dr. Fad' Hakuta." *Instructor,* 98, 10.

Horn & Smith. *Experiencing Art in the Elementary School*. Massachusetts: Davis Publications, Inc., 1971.

Hurwitz & Madeja. *The Joyous Vision: Source Book*. Englewood Cliffs, N.J.: Prentice-Hall, Inc., 1977.

Jones, Jerry Dale. *The Day School Found its Reading Glasses*. Jackson, Ohio: Liberty Press, 1982.

Kirst, Werner, and Dieckmeyer, Ulrich. *Creativity Training: Become Creative in 30 Minutes A Day*. New York: Peter H. Wyden, Inc., translation copyright 1973.

Leeper, Dales, Skipper & Witherspoon. *Good Schools for young Children*, 3rd ed. New York: Macmillan Co., 1974, pp. 356–357.

Linderman, Earl, and Herberholz, Donald. *Developing Artistic and Perceptual Awareness*, 2nd ed. Dubuque, Iowa: William C. Brown Co., Publishers, 1974, pp. 121–24, 32, 34, 148–150, 98–101.

Lowenfield, Viktor. *Creative and Mental Growth*. New York: Macmillan, 1947.

Mayer, P. E. (1989) "Cognitive Views of Creativity: Creative Teaching for Learning." *Contemporary Educational Psychology*, 14, 189–202.

McIlvain, Dorothy S. *Art for Primary Grades*. New York: McGraw-Hill, 1961, pp. 8–10.

Ragan & Shepherd. *Modern Elementary Curriculum*, 5th ed. New York: Holt, Rinehart & Winston, 1977.

Ripple, R. E. (1989). "Ordinary Creativity." *Contemporary Educational Psychology*, 14, 189–202.

Simonton, D. K. (1988). "Creativity, Leadership, and Chance," in R. J. Sternberg (ed), *The Nature of Creativity: Contemporary Psychological Perspectives (pp. 386–426). New York: Cambridge University Press.*

Solso, R. L. (1990). *Creativity. Cognitive Psychology* (pp. 439–443). Boston: Allyn and Bacon, Inc.

Soriano de Alencar, Eunice M. L. (1989). "Instructing Brazilian Teachers to Develop Children's Creative Abilities." *Gifted Children Today*, 12, 13–14.

Taylor, Barbarta J. *A Child Goes Forth*. Provo, Utah: Brigham Young University Press, 1972, pp. 40–41.

Torrence, E. P. (1974). Torrance Tests of Creative Thinking. Bensenville, IL: Scholastic Testing Service.

Torrence, E. Paul. *Encouraging Creativity in the Classroom*. William C. Brown Co., Publishers, 1970, pp. 40–53.

Tyler, Ralph, Scriven. *Perspectives of Curriculum Evaluation* (AERA Monograph I). New York: Rand McNally & Co., 1967.

Virginia State Department of Education. *The Child and Art: An Elementary Art Curriculum Guide for Virginia*. Richmond, VA: Division of Elementary Education, State Department of Education.

Wasserman, S. (1985). "Growing Teachers: Is There Life after Pac-Man?" *Childhood Education*, 61 (5), 331–335.

Jones, Jerry Dale, and Billy N. Escue.
Positive Creativity: How to Enhance
and Evaluate It. Brentwood, TN:
Creative Innovations, 1990. Print.

(MLA)